CELTIC PATTERNS
PAINTING BOOK

Aidan Meehan, born and raised in Newry, Co. Down, Northern Ireland,
now lives in Vancouver, B.C., Canada. Since 1991 he has produced
the eight volumes of the *Celtic Design* series of books
published by Thames and Hudson.

CELTIC PATTERNS PAINTING BOOK

by

AIDAN MEEHAN

T & H

**THAMES AND
HUDSON**

Dedicated to my Mom, who showed me how to draw,
and to my Dad, who showed me how to letter.

artwork and typography copyright © 1997 Aidan Meehan

British Library Cataloguing-in-Publication Data
A catalogue record for this book is
available from the British Library

ISBN 0-500-27938-1

Printed and bound in Spain

CONTENTS

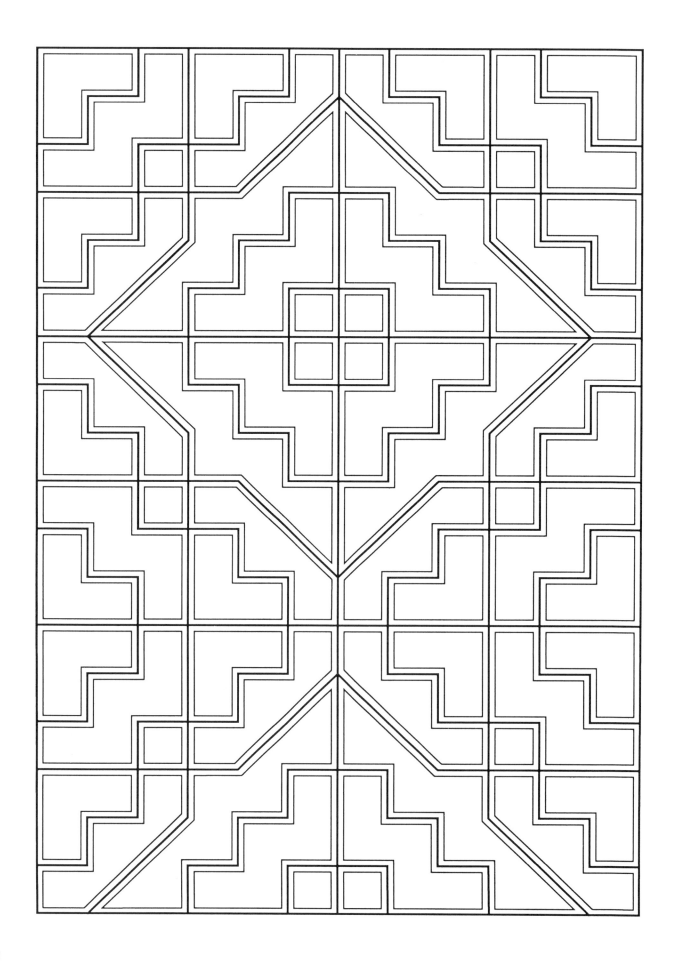

STEP PATTERNS

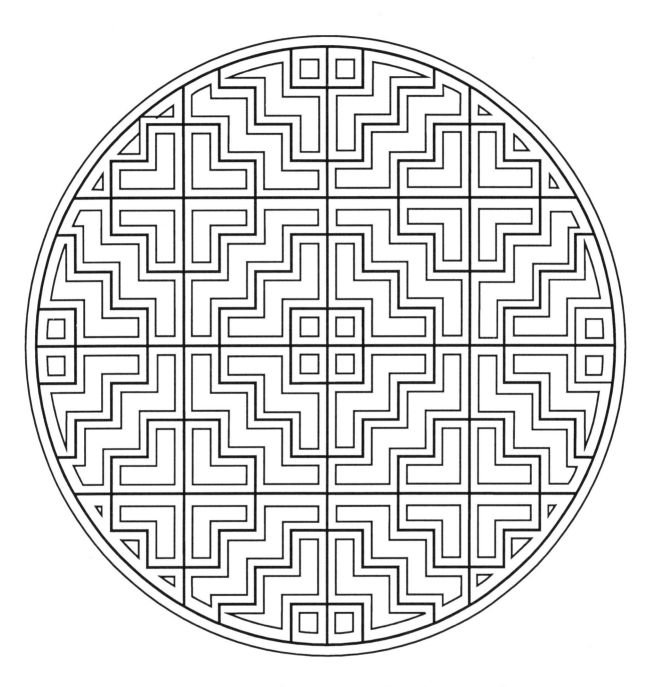

Step patterns: paint the stepped cells in alternating colours. leave their surrounding contour bands empty, or paint them yellow. This one above may be painted in two alternating colours, the one opposite in three.

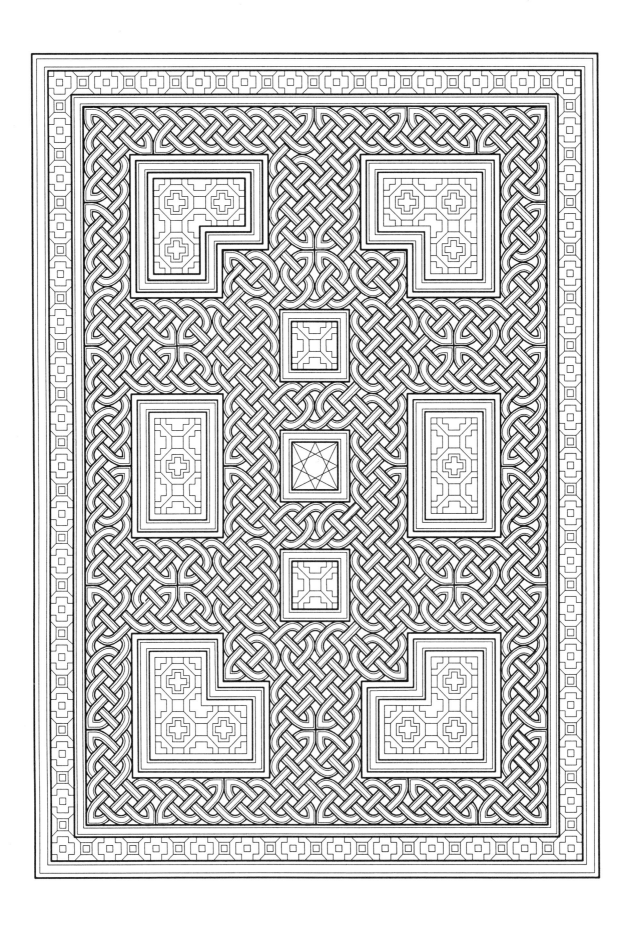

KNOTWORK PATTERNS

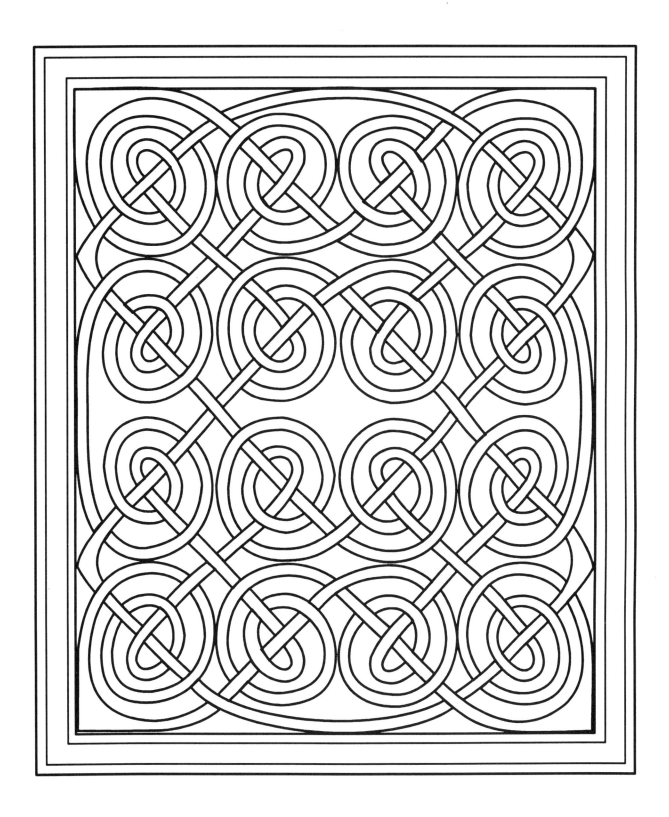

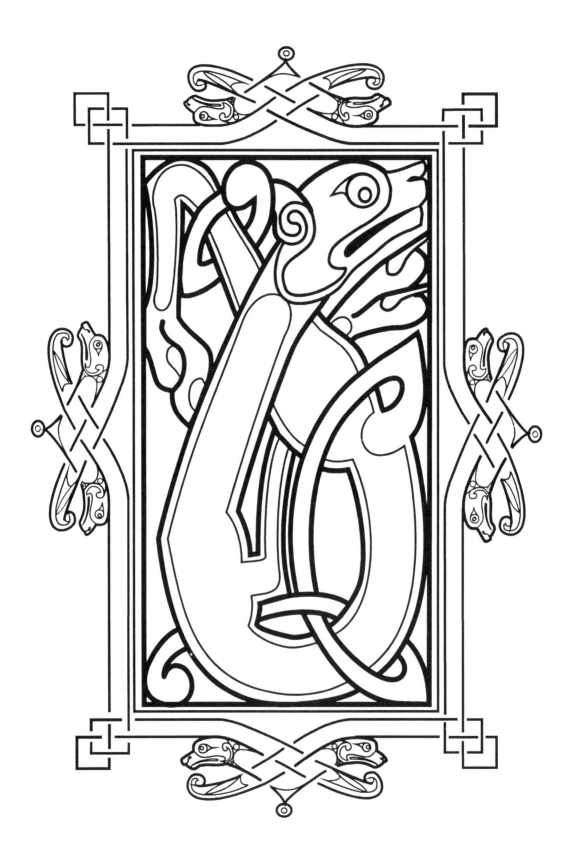

ANIMAL PATTERNS

NIMALS carved in stone were often painted in the Middle Ages. The paint has long since faded, but we know from books of that time how they looked: the tail, paws and thin band all round the body's edge were done in yellow, the body inside the edge band usually red or blue-green. The cheek was painted white or left empty. The background was black or brown. Claws and snout were sometimes painted orange, or left empty.

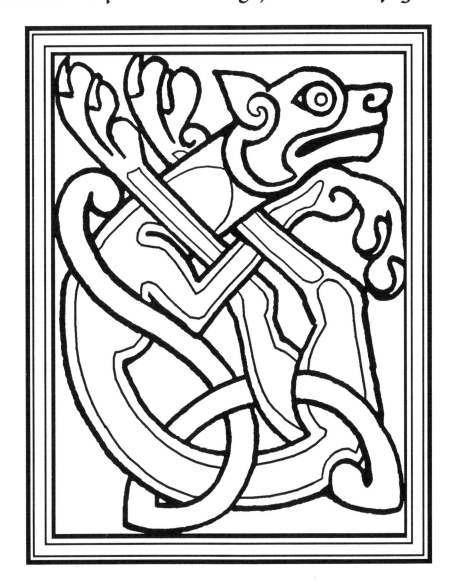

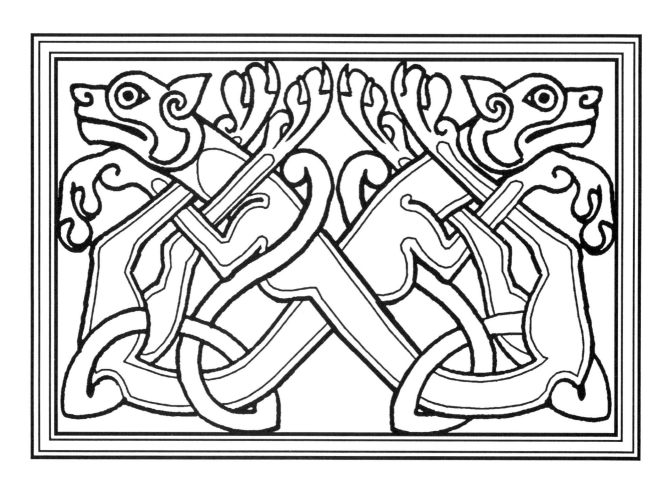

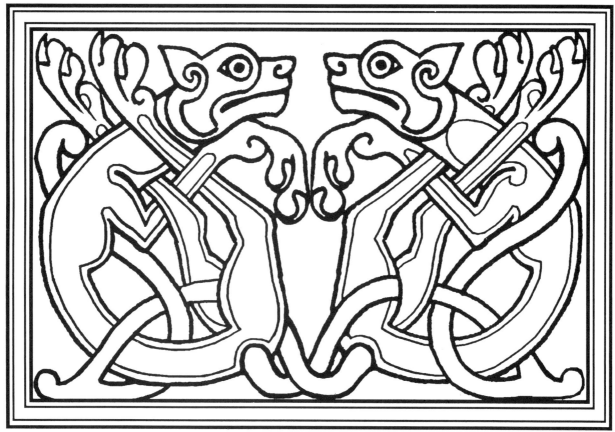

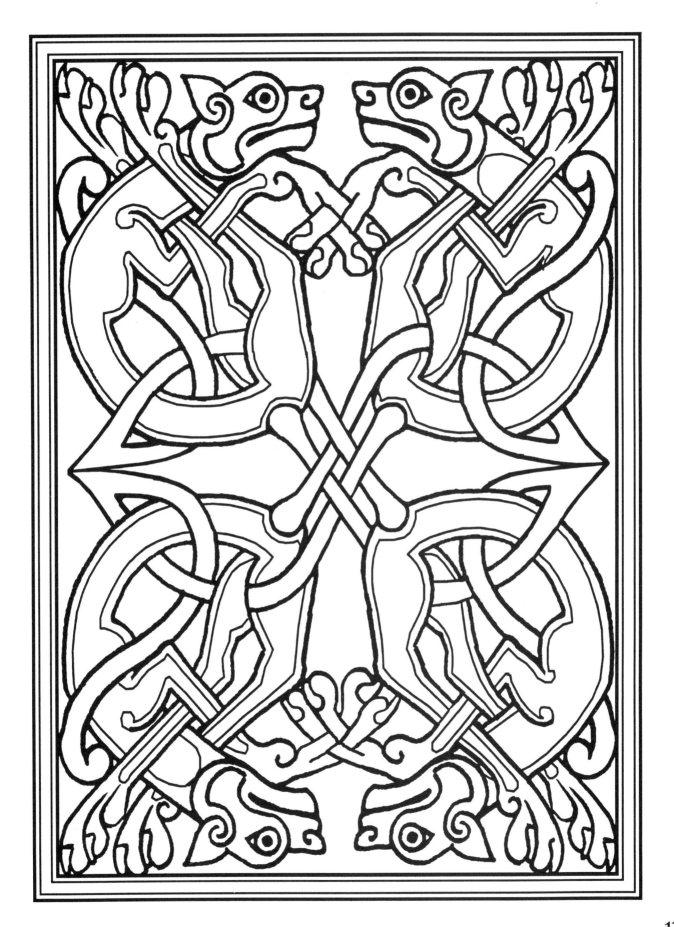

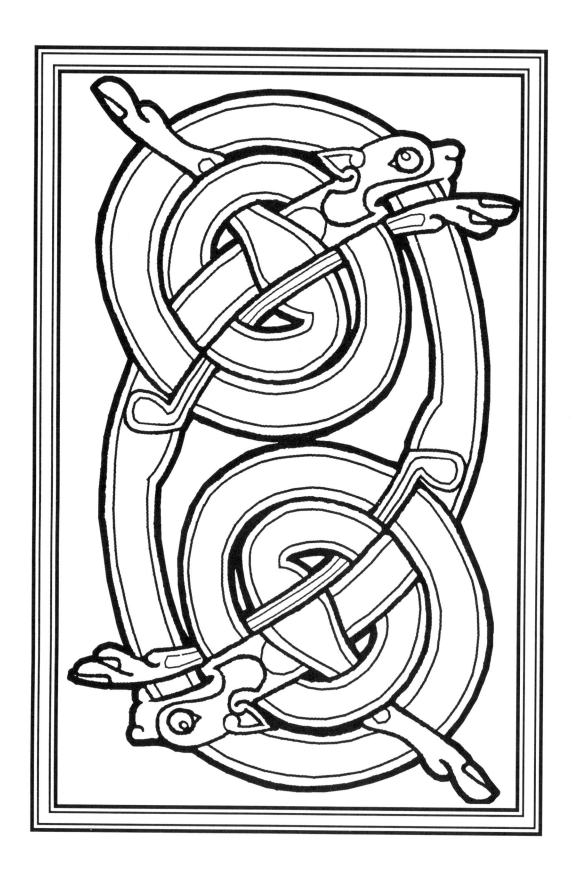

14

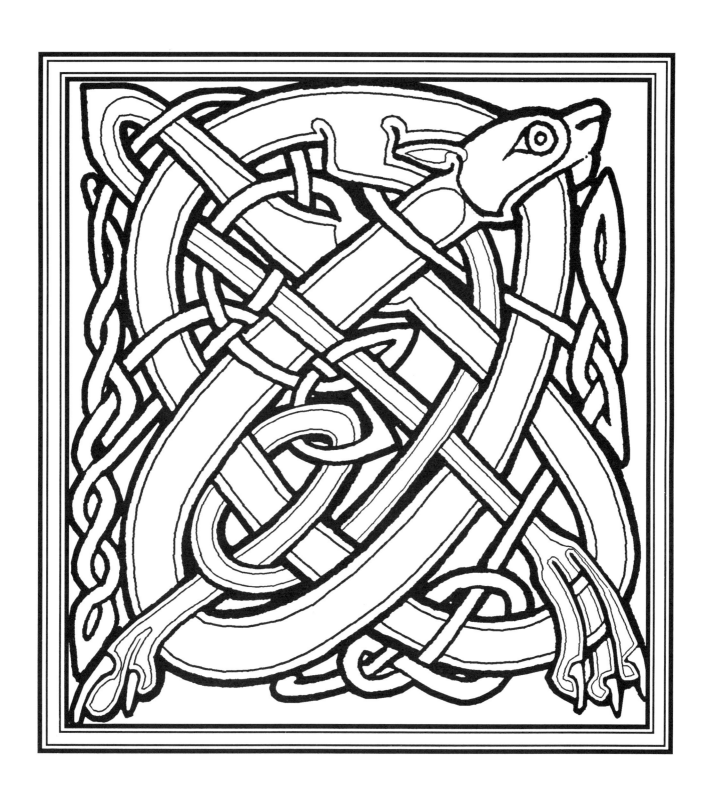

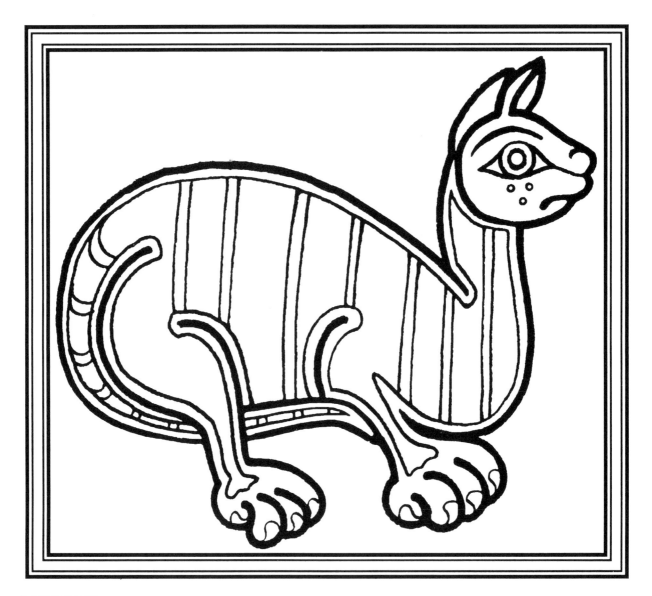

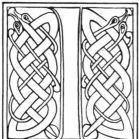 N THE BOOK OF KELLS, AD c. 807, the wide stripes of this tabby cat are painted with lemon yellow and bright, intense blue with a cool blue – green stripe running into the front leg, and a blue one running into the back leg. The broad body stripes between the legs are yellow, blue, yellow. On the tail they are yellow. The claws are black. The narrow stripes are left empty, as is the contour band around the body, and the head. The background is empty. If you colour the background dark, leave the claws empty or white.

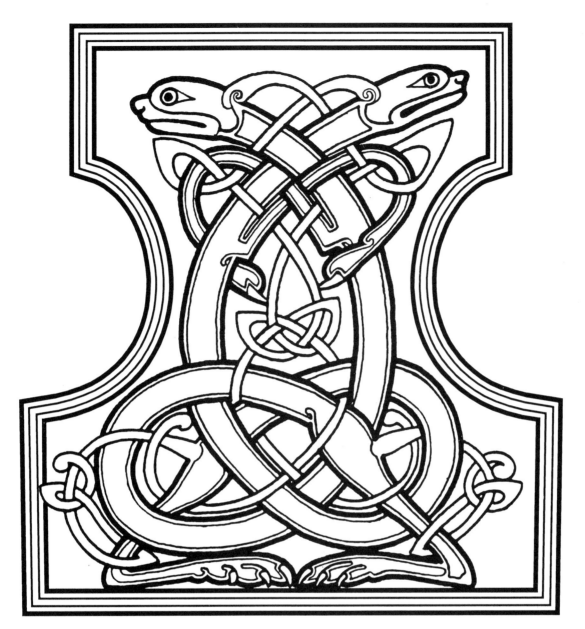

 HESE ANIMALS were originally painted with tan bodies, with purple blotches on the back and on the bends. Maybe the paint had worn off. Or maybe the artist had a tortoise-shell cat. You don't have to paint it all the same colour; you can add a spot of purple before the tan paint is dry and let it spread, like the marking on fur. The background may be painted red ochre or black.

BIRD PATTERNS

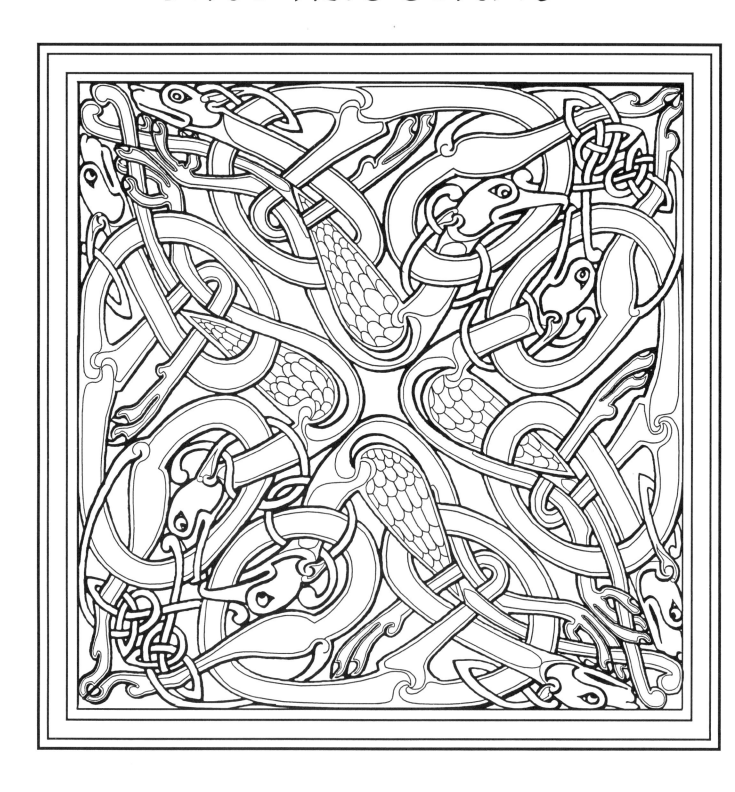

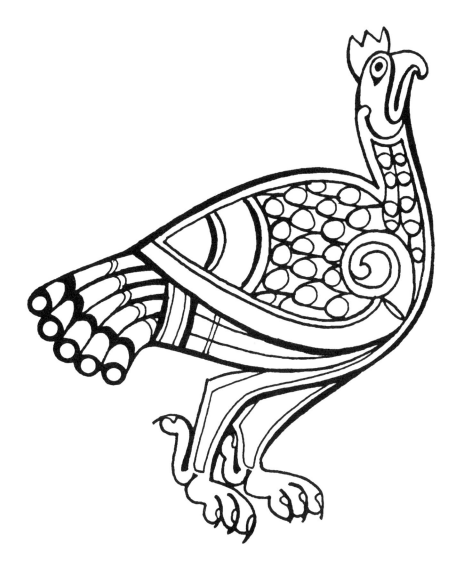

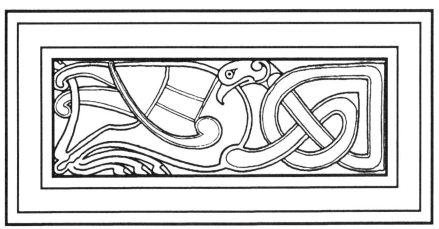

EMEMBER, on small figures leave the thin edge contour empty.

Leaving things empty is like having an extra colour.

Necks, tail feathers and body may be painted in a bright red, green or blue. In the band across the wing, you can do whatever you like.

The birds at the bottom of this page look the same, only flipped around. How many differences between these two birds can you count?

Do the larger birds here before trying the little ones on the next page. Use a small pointed brush to paint fine details, or a sharp coloured pencil, or fine pointed pen. Keep your brush sharp, wash it often.

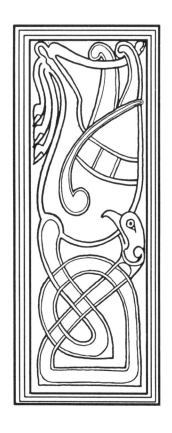 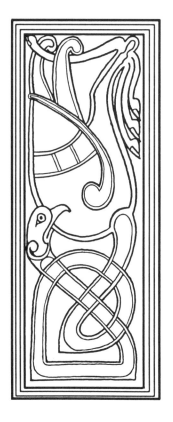

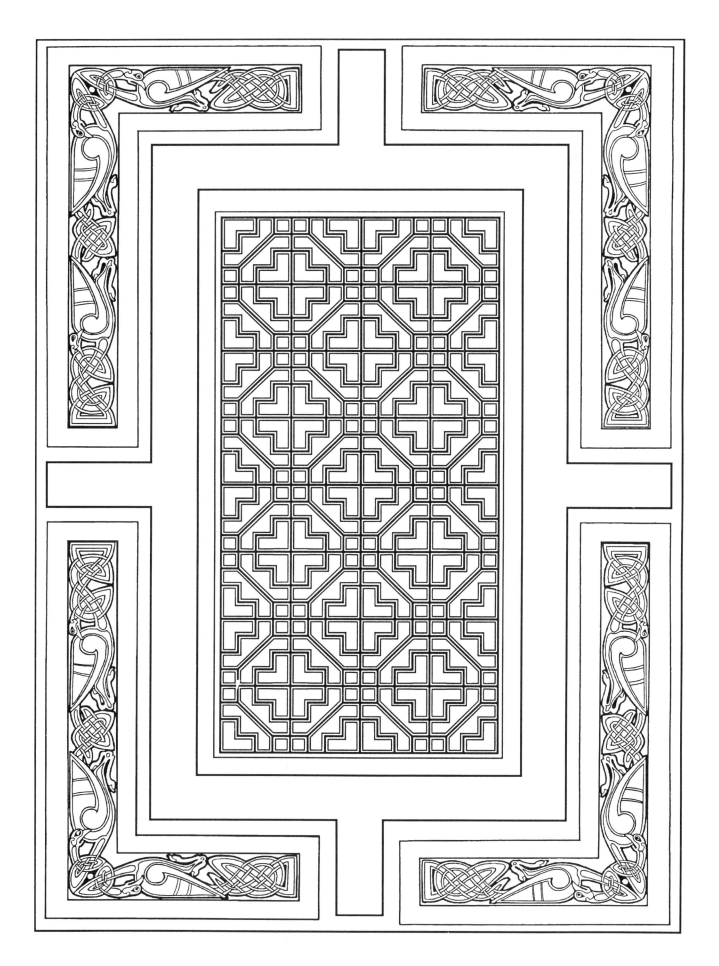

ILLUMINATED LETTERS

ATURALLY, painting animal patterns next to words led to drawing animal-shaped letters themselves.

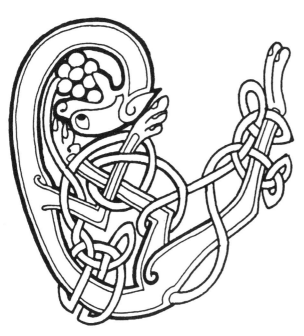

Here on the left is a letter from an alphabet of lions. Can you "see" which letter it is?

It is also a lion, with its tail in a knot. The cheek is golden yellow, as is the tip of the ear, blending into white at the spiral earlobe.

The edges of the body are white. The background is pink. The body is orange, the paws are white.

The leg with which the lion scratches its nose may be painted another colour, or orange as in the original. The berries are green and yellow and white.

In the Book of Kells, the berries grow on the Tree of Life which weaves behind the letters and comes out of a little flower pot, which you can see here at the very top, along with four letters of the name, ZACHARIUS. Turn the page sideways to read it better.

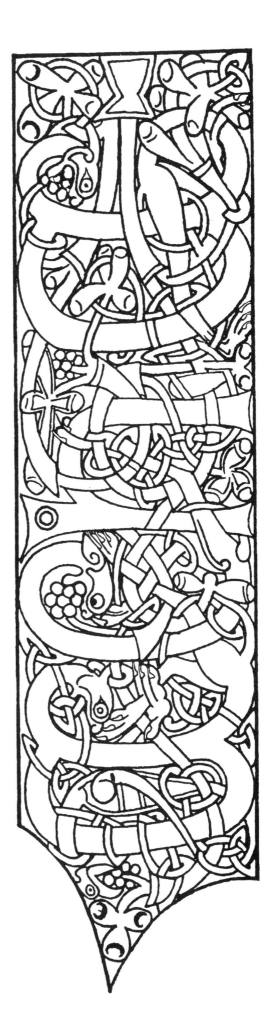

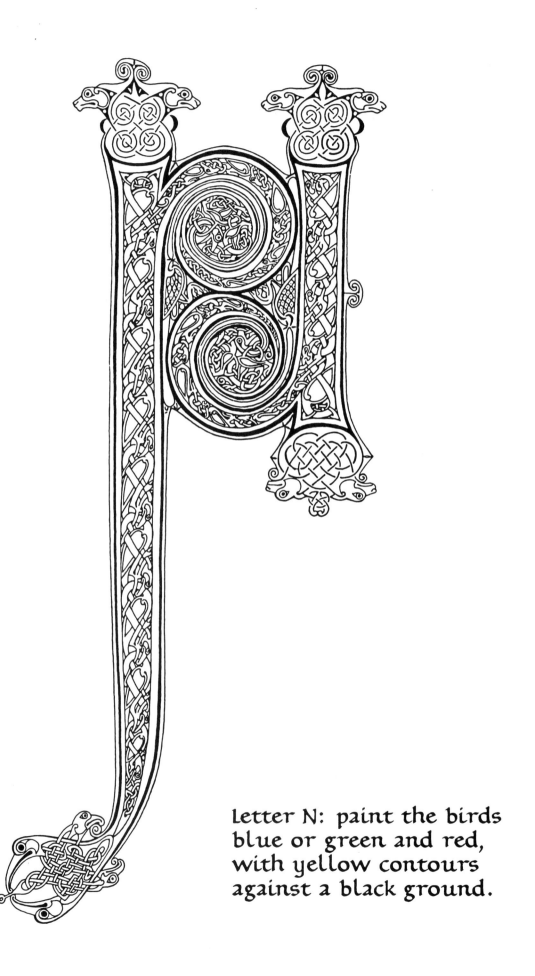

Letter N: paint the birds
blue or green and red,
with yellow contours
against a black ground.

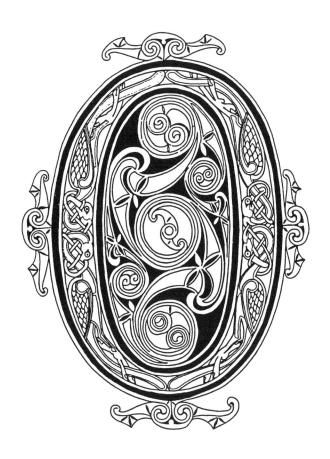

letter O: paint the inlined trumpets in two alter-
nating colours. Do the backgrounds of the spiral
centres and birds a bright pink or green, tinted with
a touch of white added to your paint.

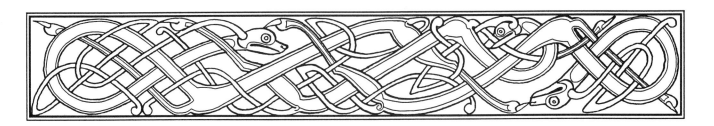

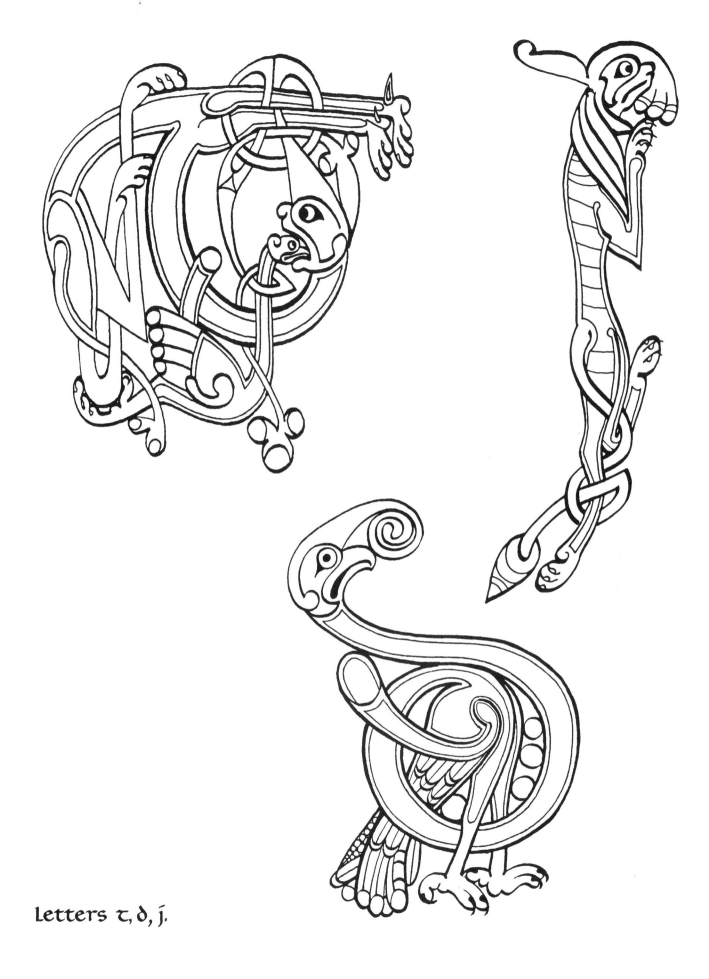

letters τ, ð, ȷ.

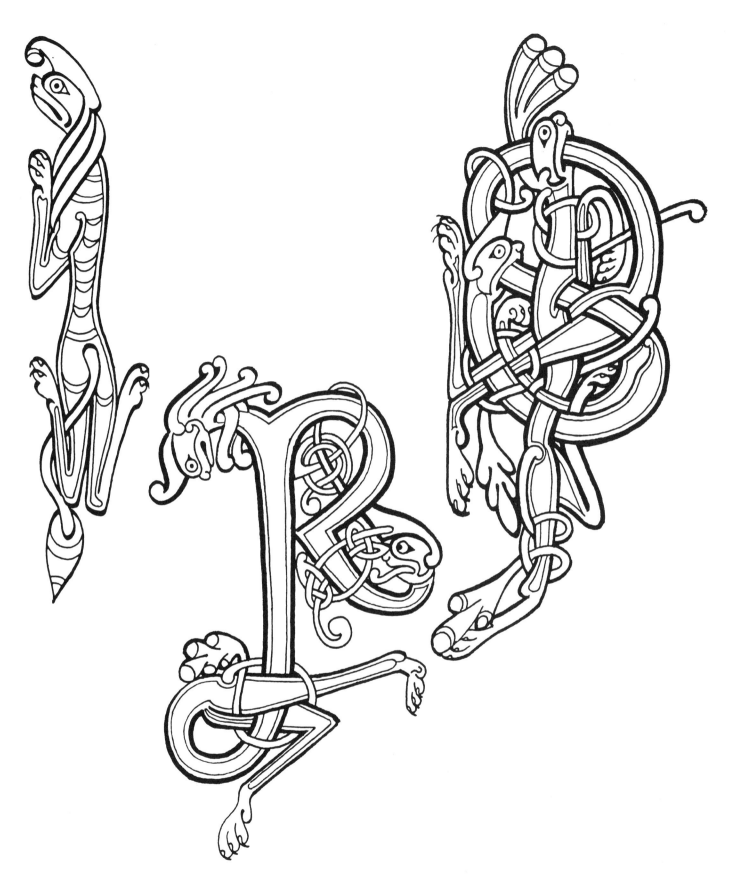

letters í, r,
and monogram sl

letter b

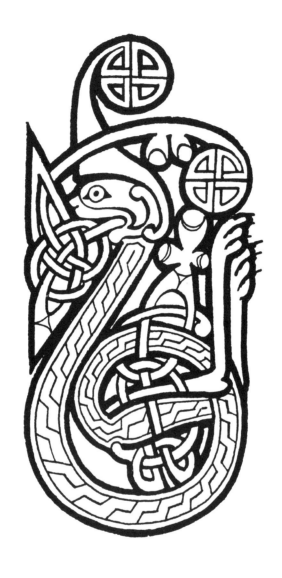

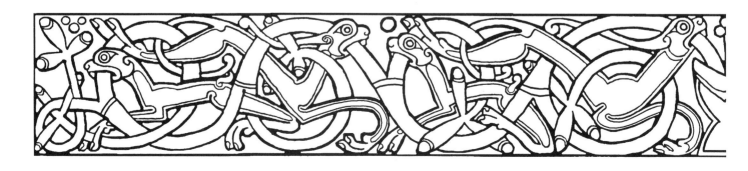

letter v

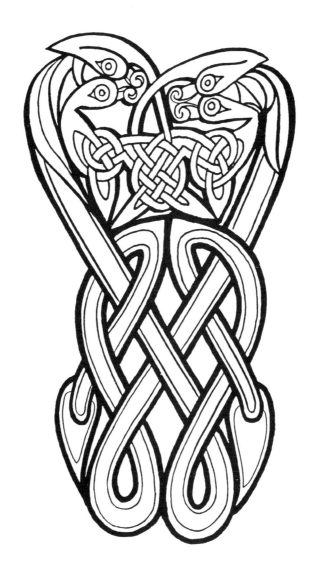

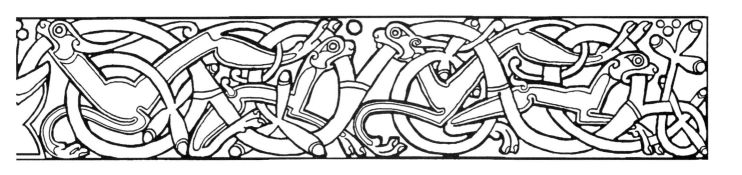

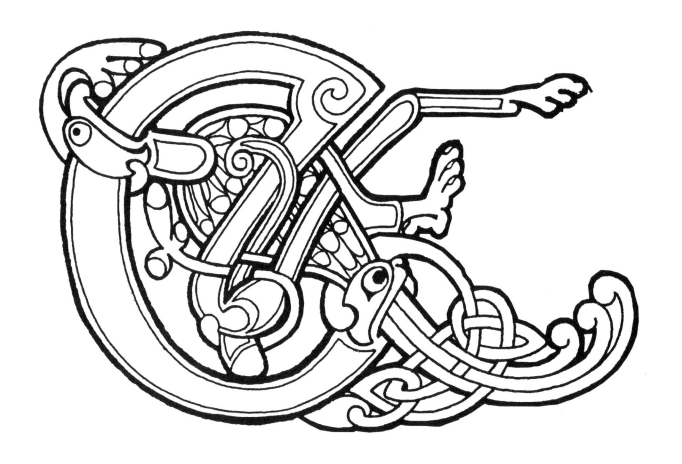

 N THIS PAGE, a lion and a bird form the two letters, Є and Ͳ, which go together make the character called the ampersand, or "&".

On the next page, a two-headed sea serpent, or eel, makes up the same two letters. The crossbar of the Ͳ floats over the second eel, whose tail runs into the crossbar of the Є.

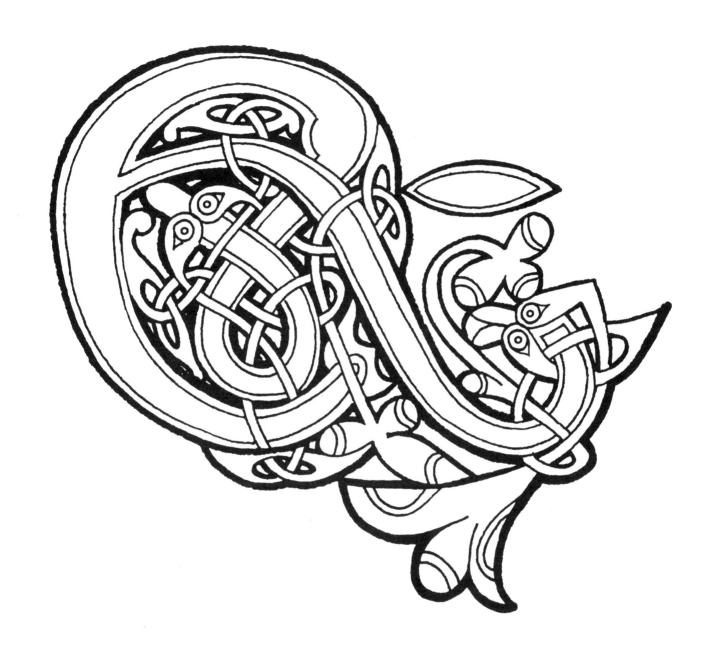

You can tell this is a sea creature by its fish-tail
and also by its cheeks, which open out like gills. At
the island monastery where this design was first
created, eels were a common sight. They come out of
the rivers, too, and cross over the land: creatures of
two worlds, like the water birds that hunt them.

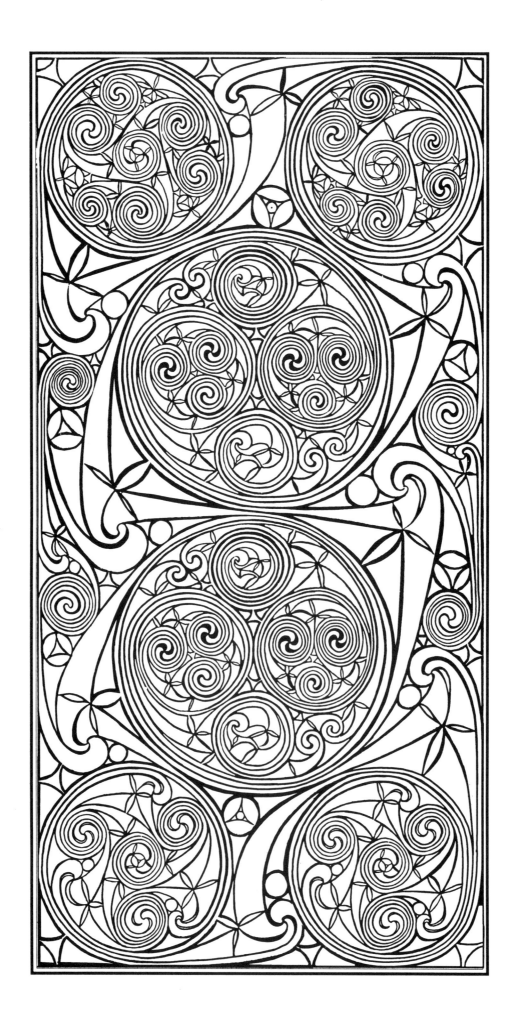

SPIRAL PATTERNS

 HE ABBEY of Durrow produced the famous book that bears its name in 650 AD, and from which I drew this wonderful panel of Celtic spirals, opposite.

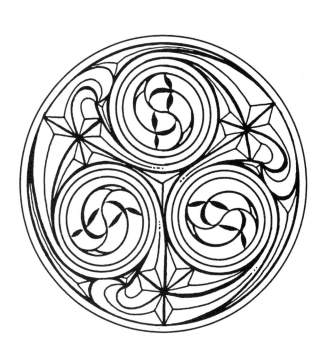

Paint the background first. Add a drop of red and yellow to your black paint for the background colour. Leave empty the coils of the spirals and the wider paths joining them, which are called trumpets. Paint the leaf shapes white on the black background. Fill the leaf-shaped trumpet mouths with black.

After the background is filled, trumpets between the spirals may be painted, alternating red, yellow and green, leaving a thin contour at the edge.

 O paint this spiral, first wash it in yellow. The triangular shapes are divided into three parts. Put brown in the top, green on the left, and white on the right side of downward-pointing triangles. Put brown on the left, green on the right and white on the base side of a triangle pointing up.

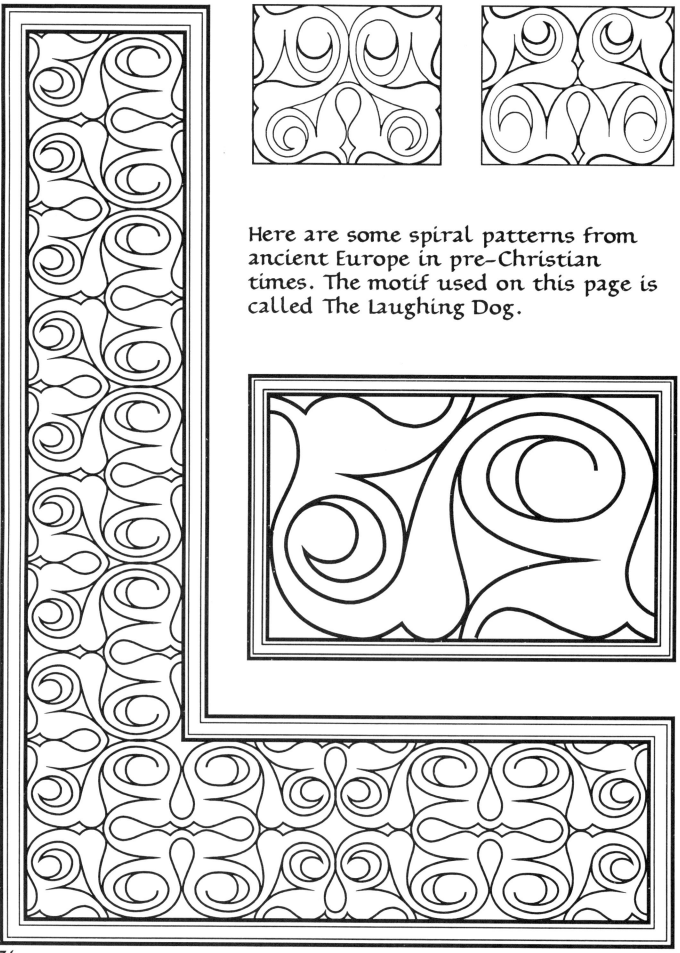

Here are some spiral patterns from ancient Europe in pre-Christian times. The motif used on this page is called The Laughing Dog.

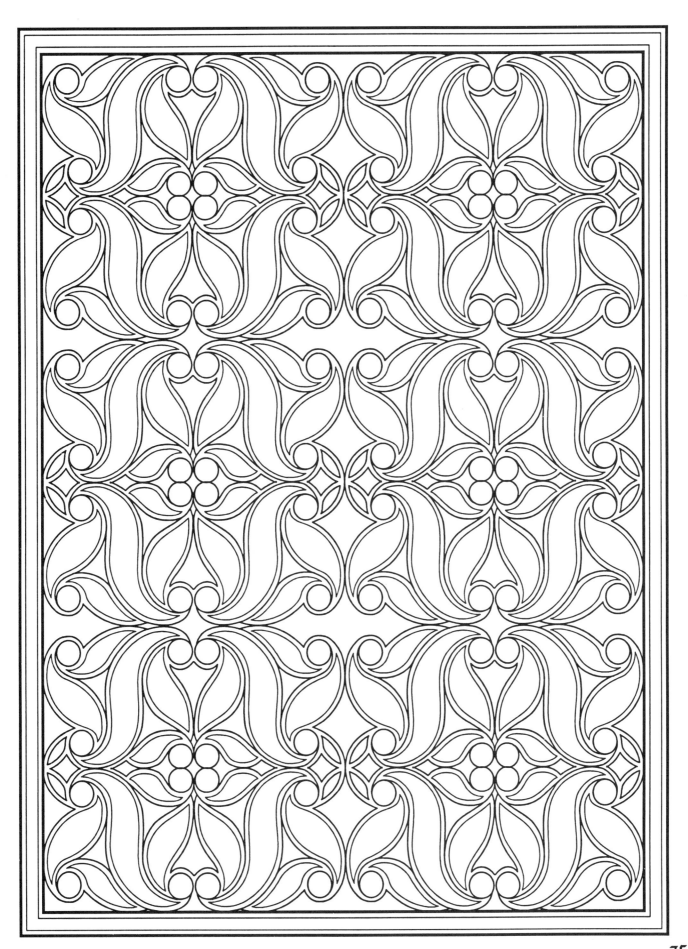

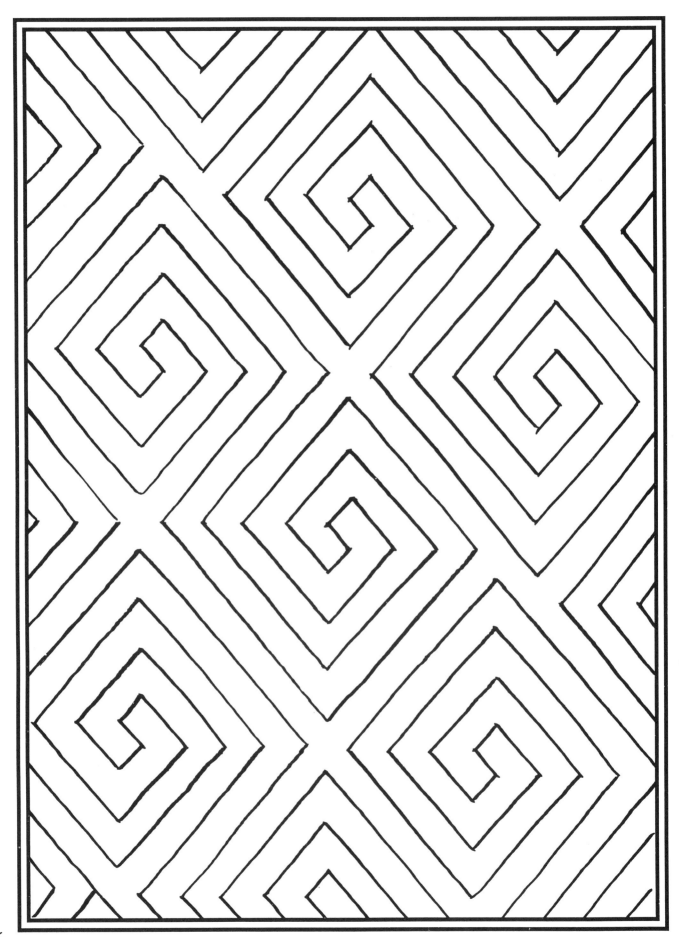

36

CELTIC MAZE PATTERNS

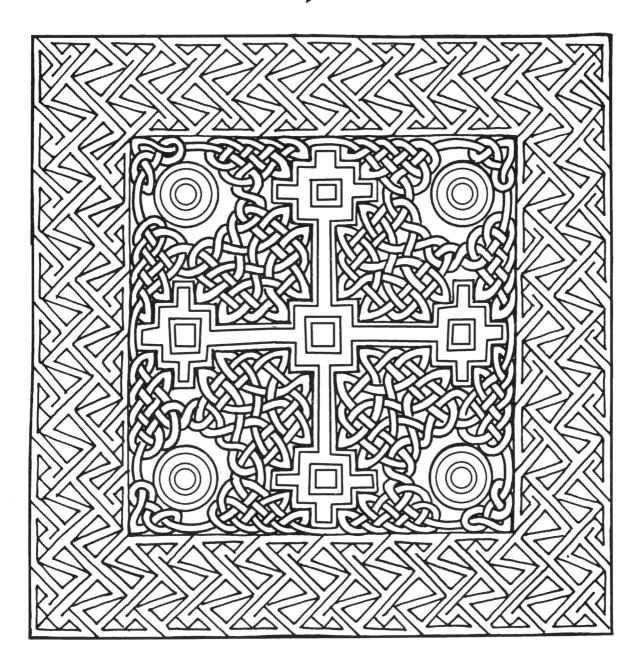

Opposite: a maze pattern from the late Stone age, from which Celtic maze patterns are descended.

Celtic mazes are multicursal: they have many paths, not just one. Paint the background all one colour, or make a chequered or striped background of two or more different colours.

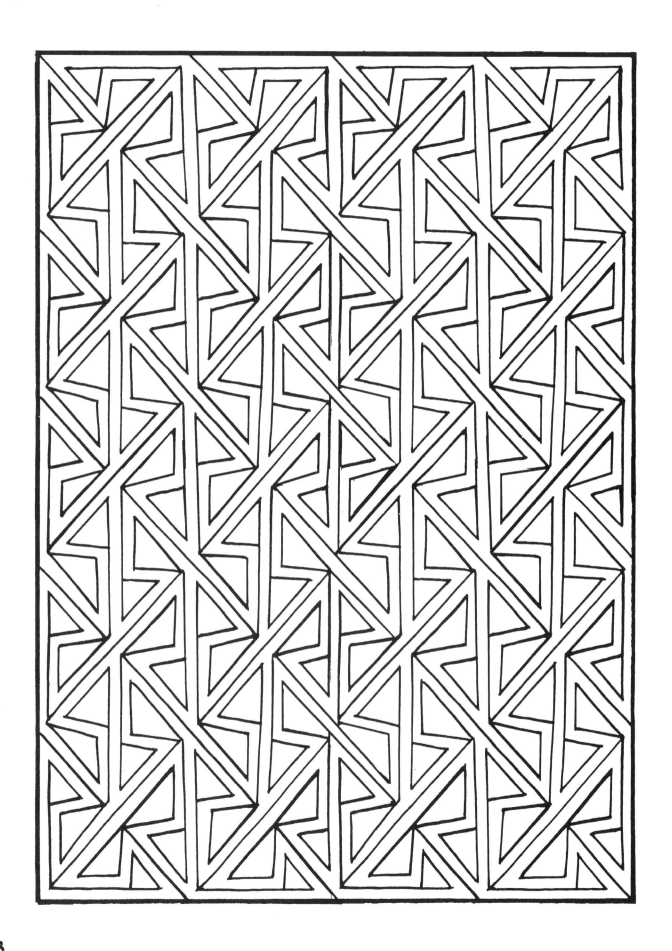

38

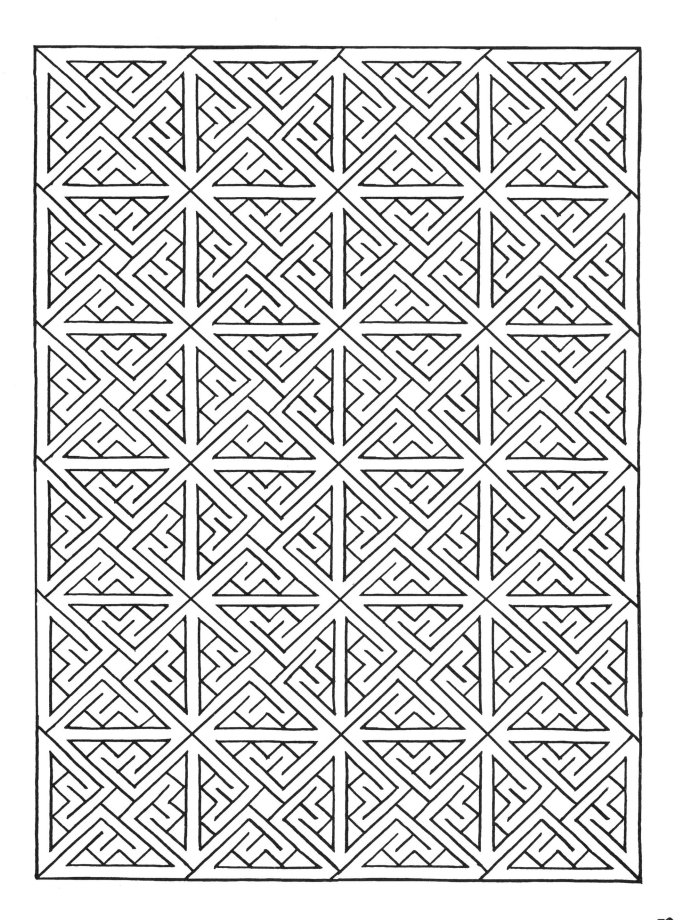

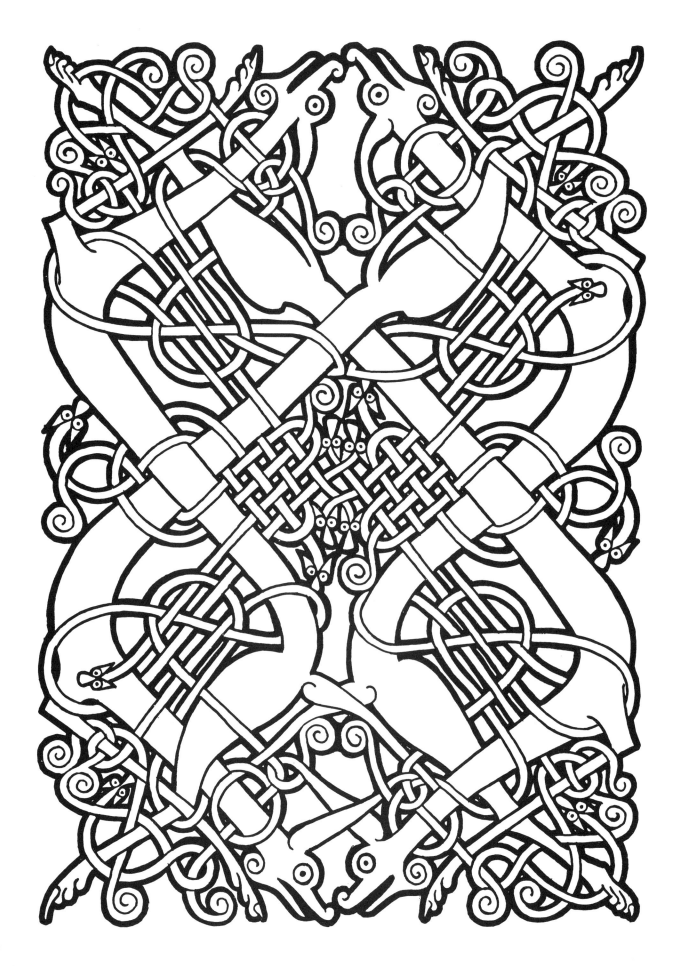

DRAGON PATTERNS

FTER THE VIKINGS, the eel that until now had but rarely been used in a few illuminated books and sculptures of the early Christian period, suddenly hatched into these fantastic dragons, such as I have here redrawn from Late Medieval Irish sources.

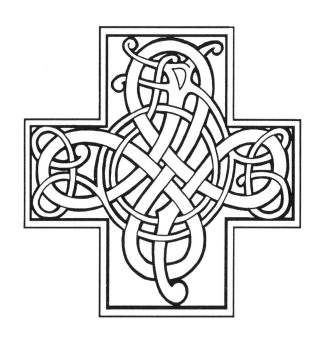

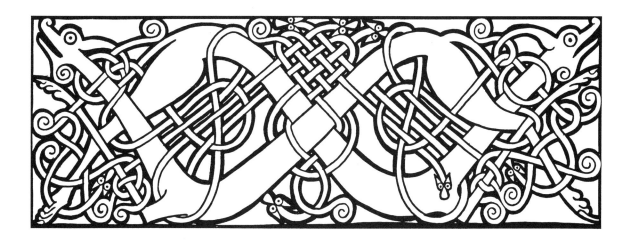

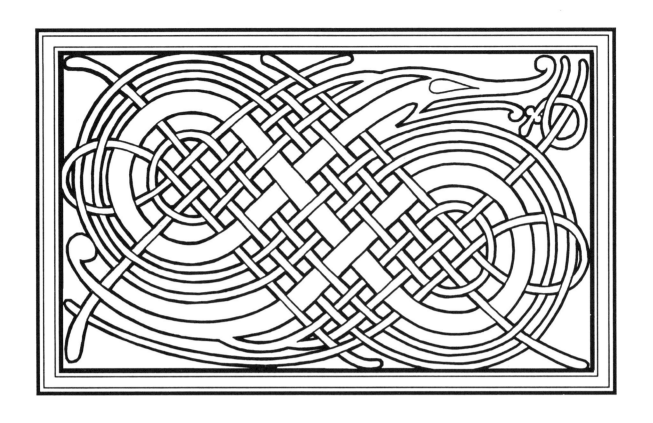

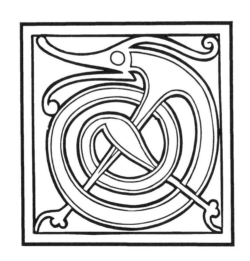

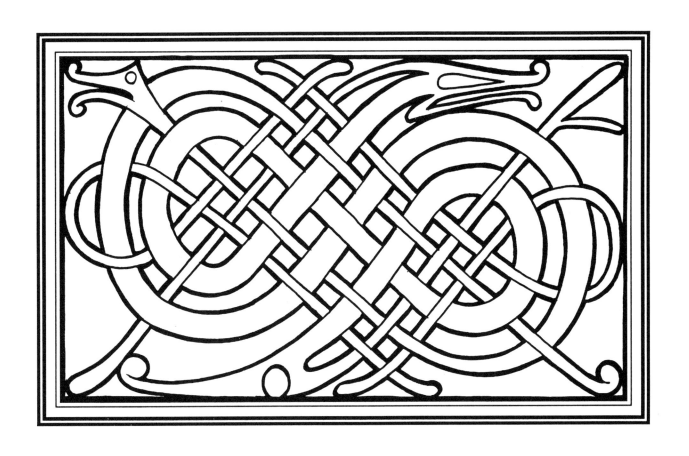

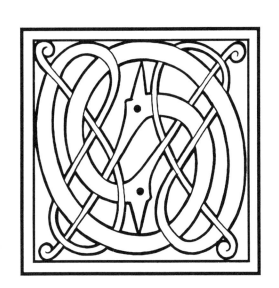

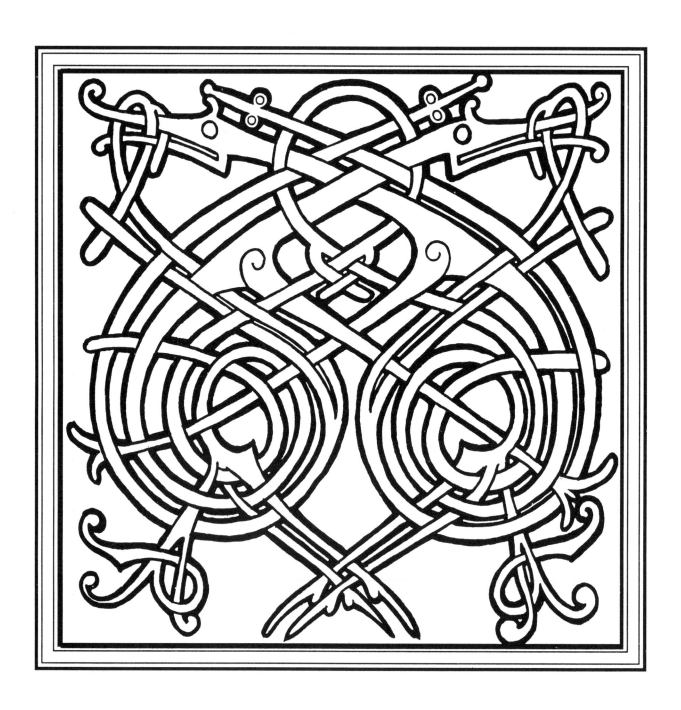

44

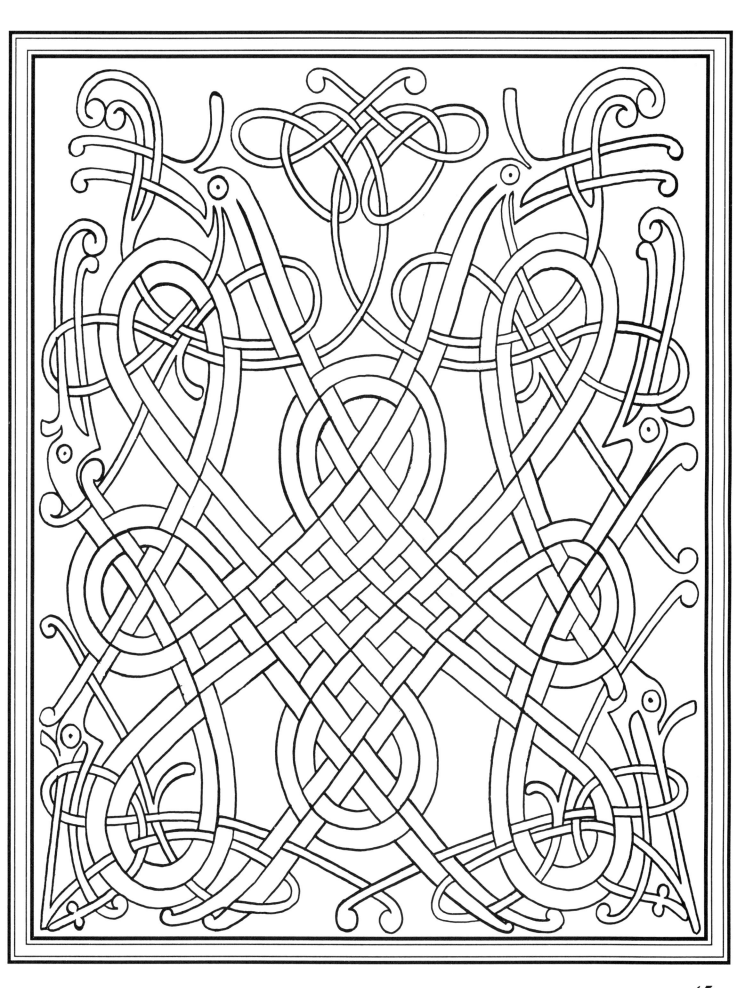

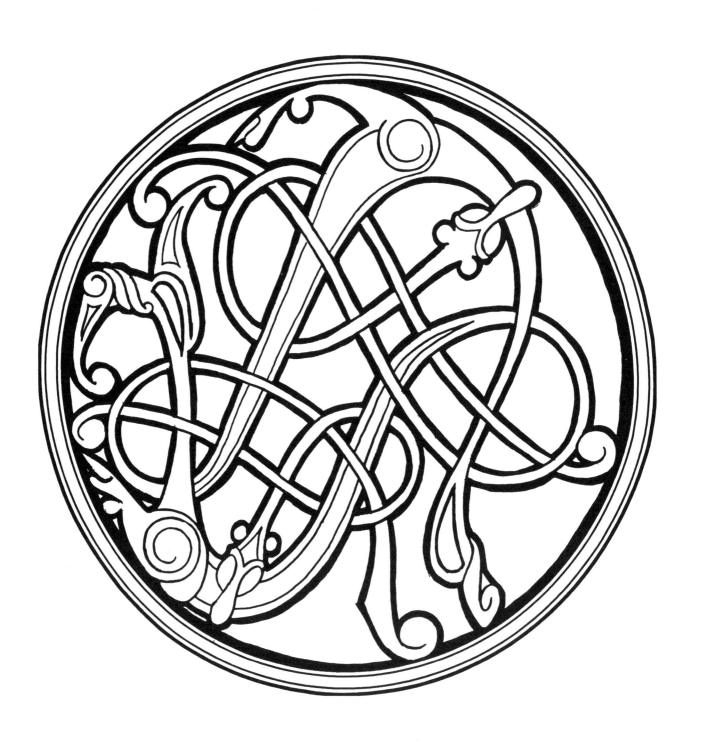

46

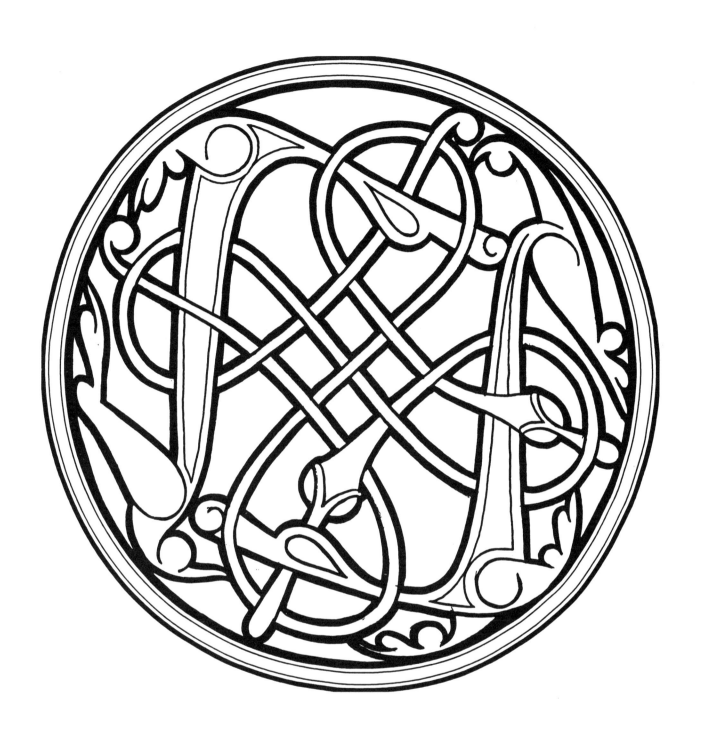

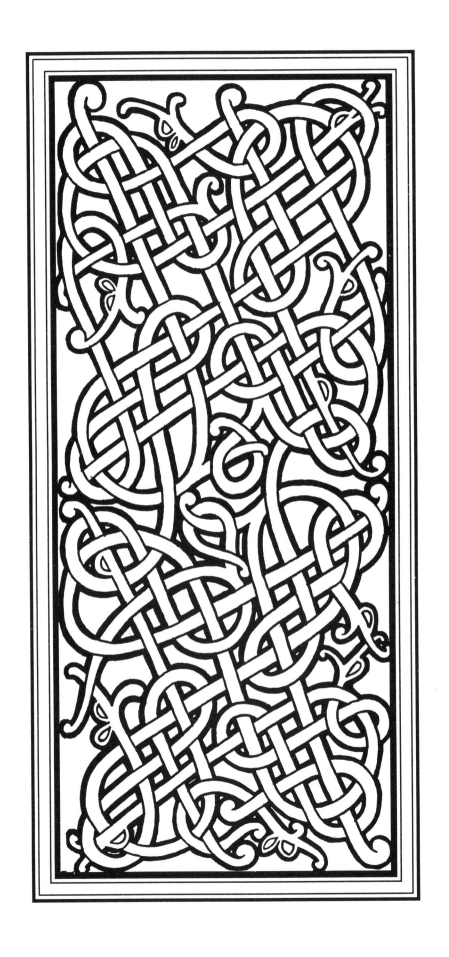

48

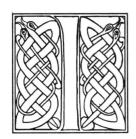

N LETTERING, a new style developed, such as this h. A vermilion background is painted all round so that the letter pops out of a big red splash, with white claws, yellow contour, paws and tail, an orange mane and muzzle, and blue or purple body.

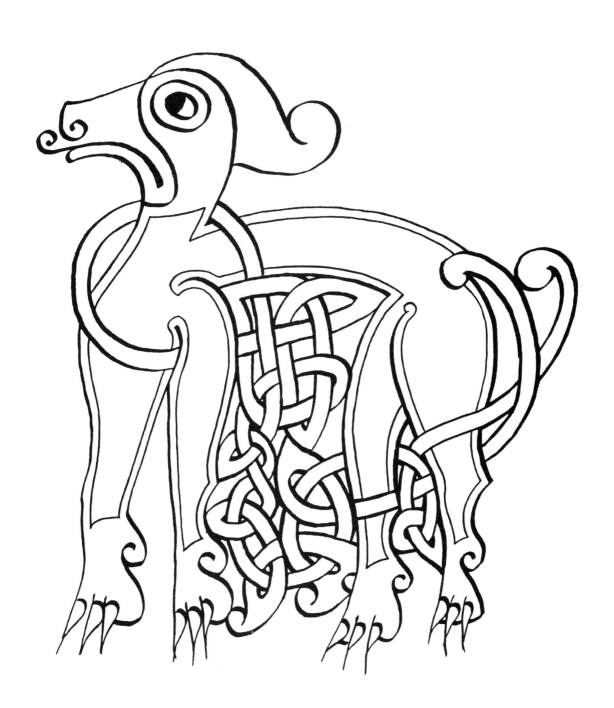

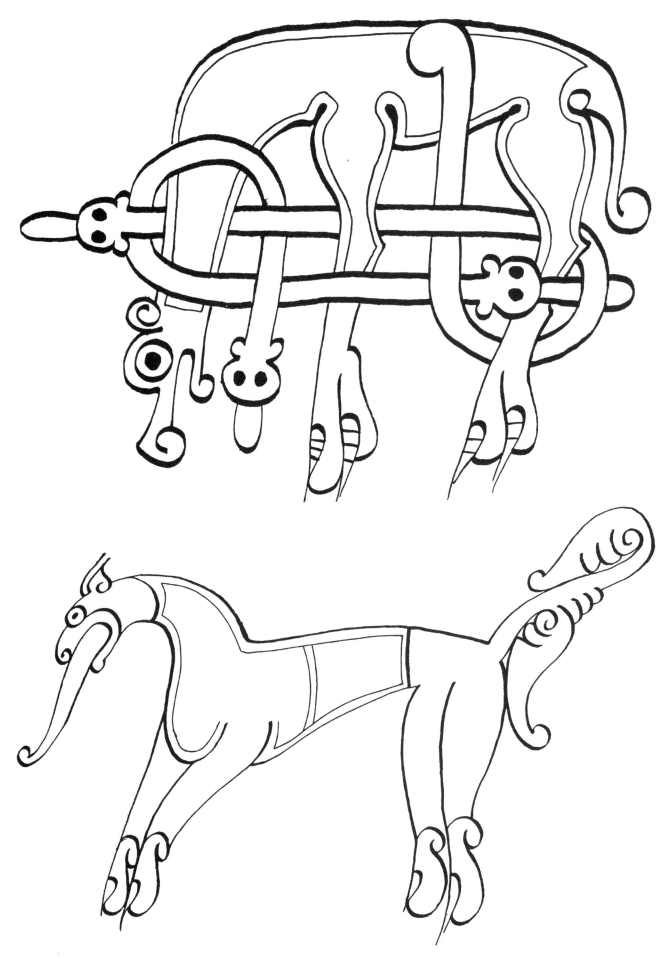

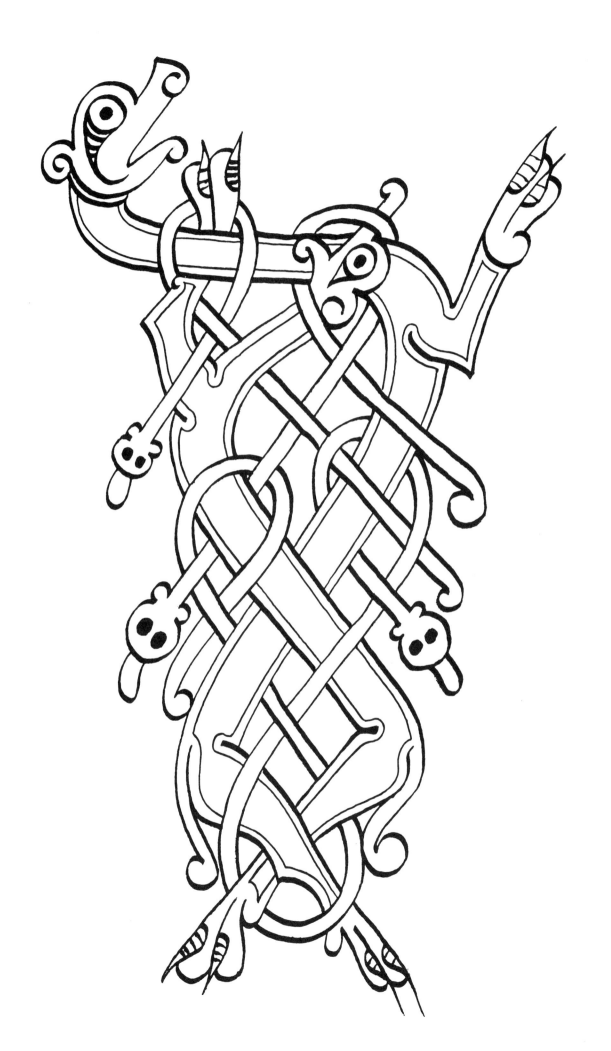

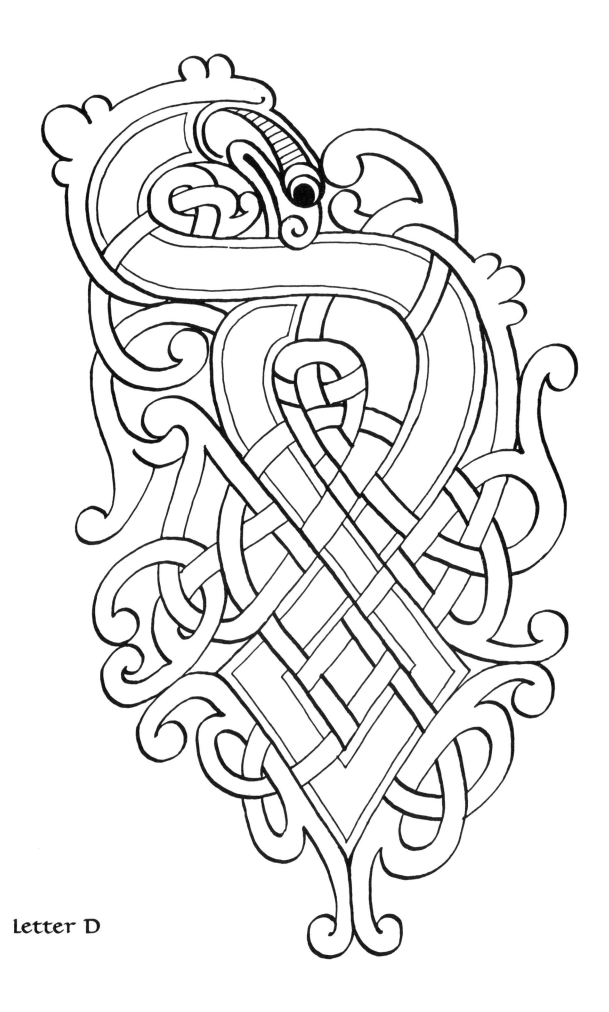

letter D

52

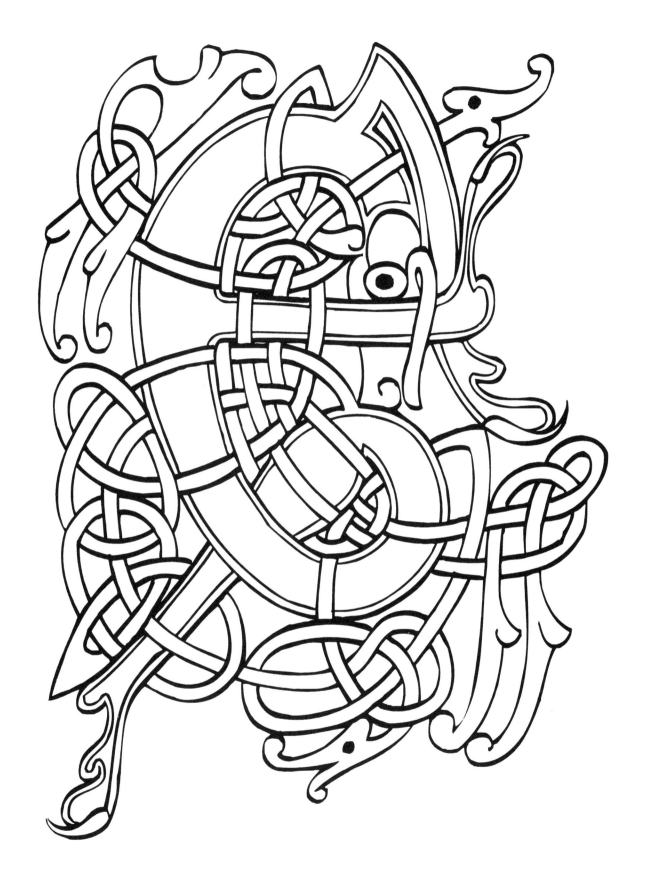

Letter E

PEOPLE PATTERNS

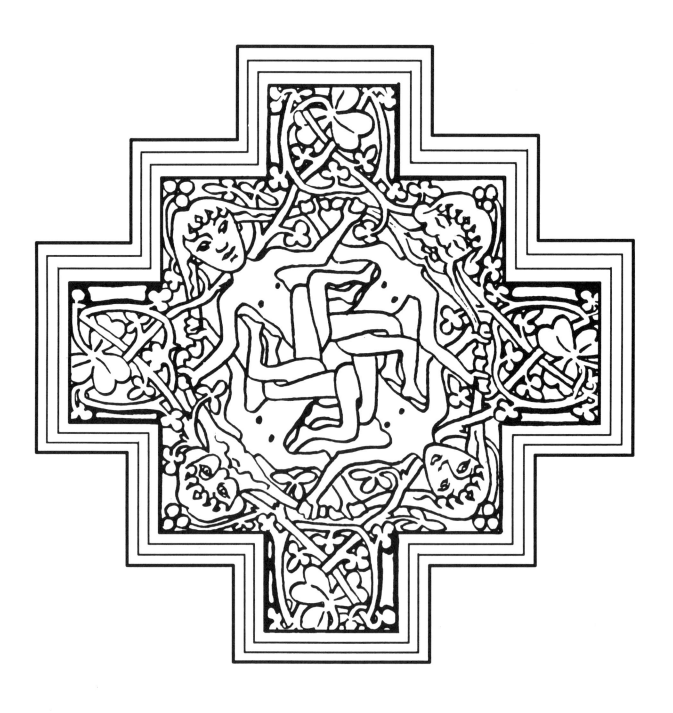

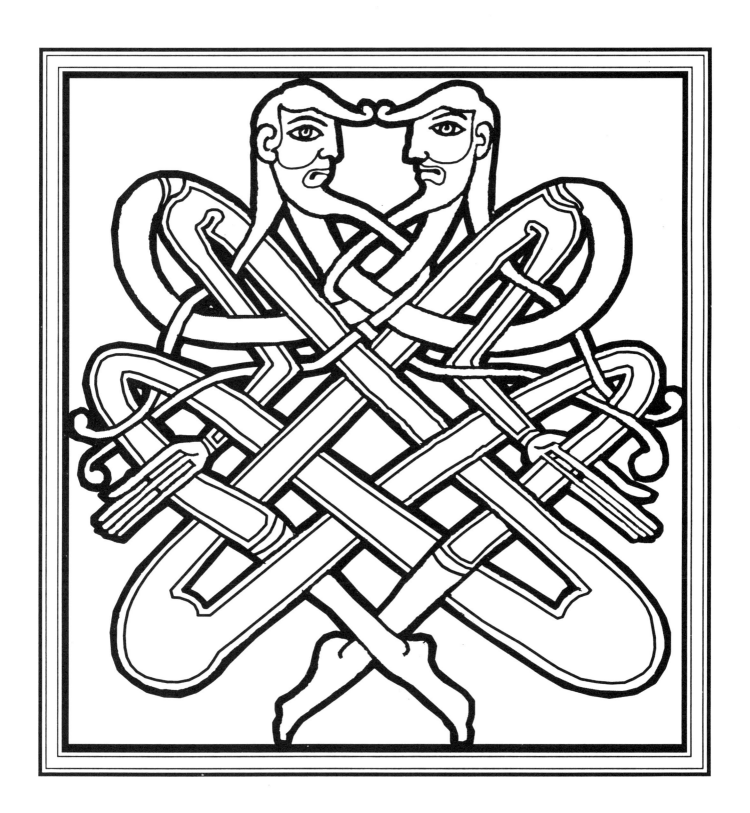

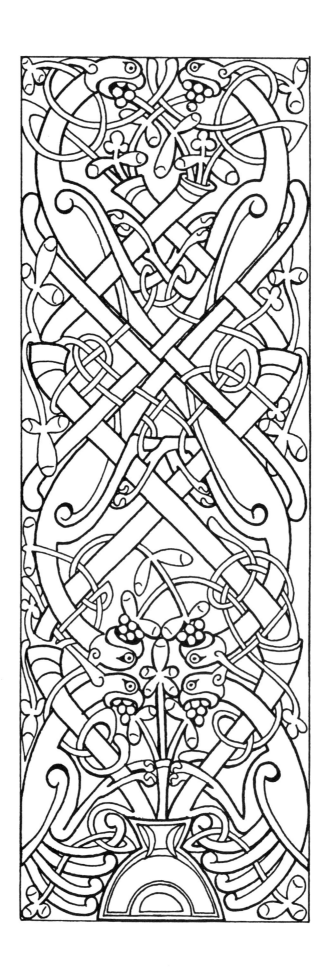

56

TREE OF LIFE PATTERNS

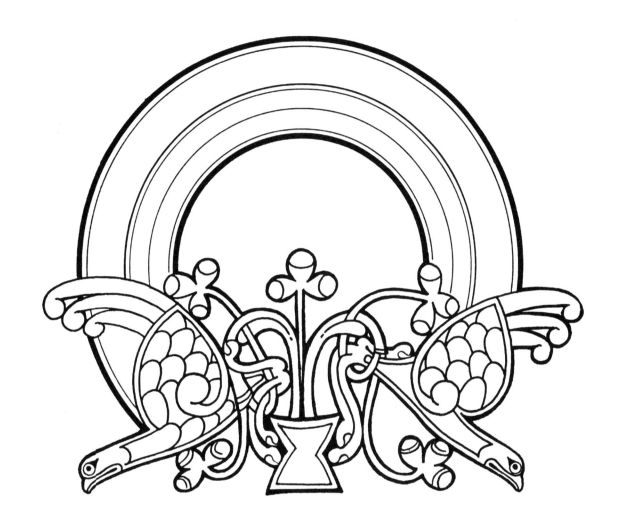

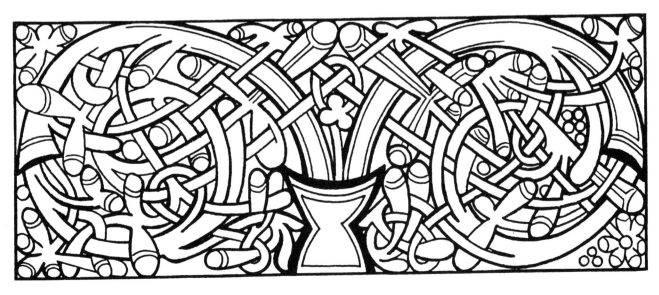

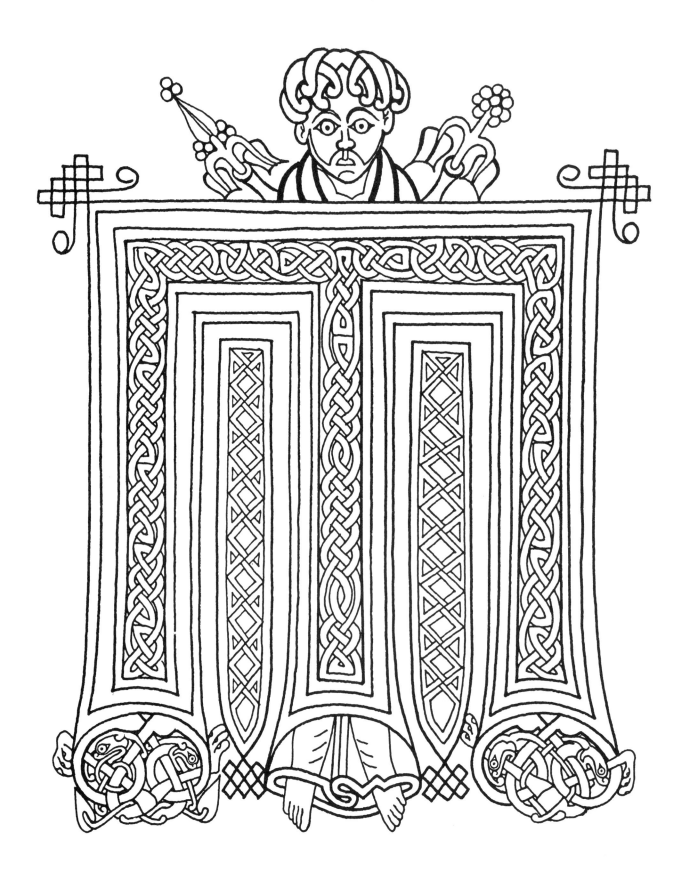

In the old books, the Tree of Life is often shown as a flowering rod in the hands of an angel or saint. It was also used in combination with illuminated letters, as a background filler, weaving through the decorated text, such as the letters RIN, below.

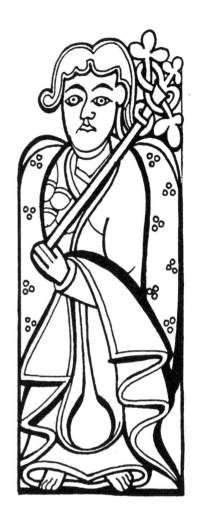

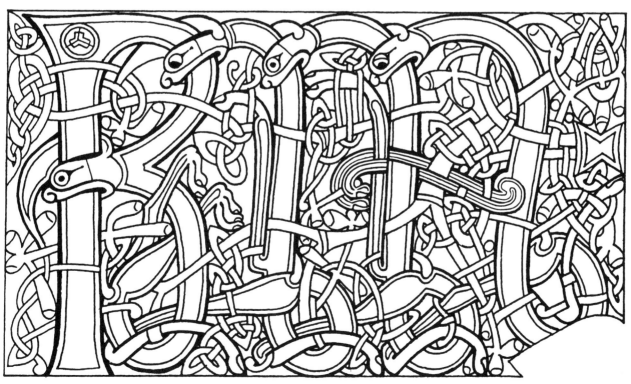

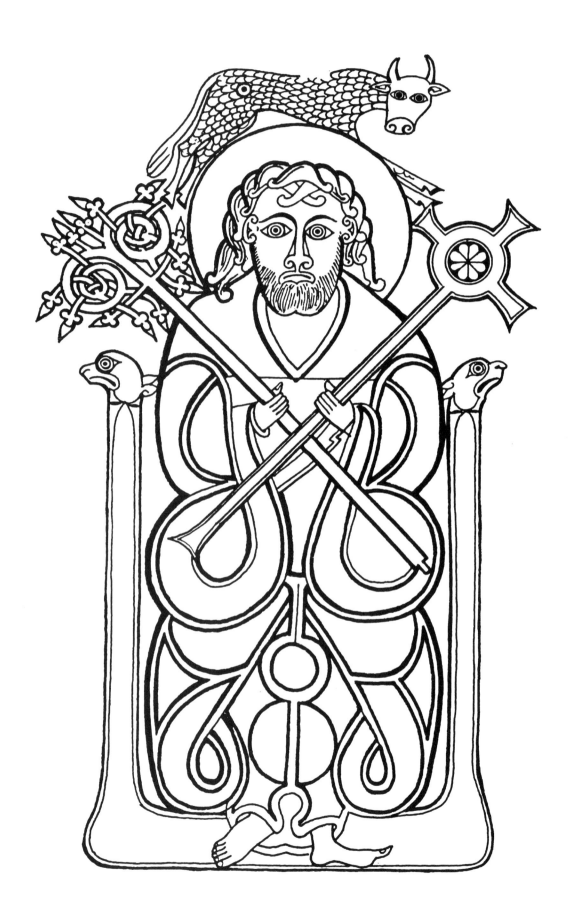

This old gardener holds a flower, which he has just cut with the knife in his other hand. Perhaps he is the gardener of Eden, where the Tree of Life is said to grow. His strange apron is made of the skins of three animals, the Lion, the Calf, and the Eagle. These three animals are the symbols of the evangelists, Mark, Luke and John, while the Man himself is the symbol of Matthew.

On the previous page, the evangelist Luke is shown enthroned with his symbol, the Calf, overhead. He holds a branching rod and flower-centred cross in the form of the letter X.

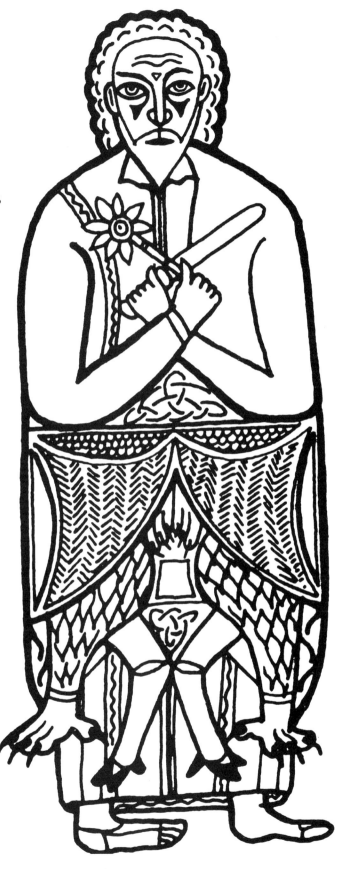

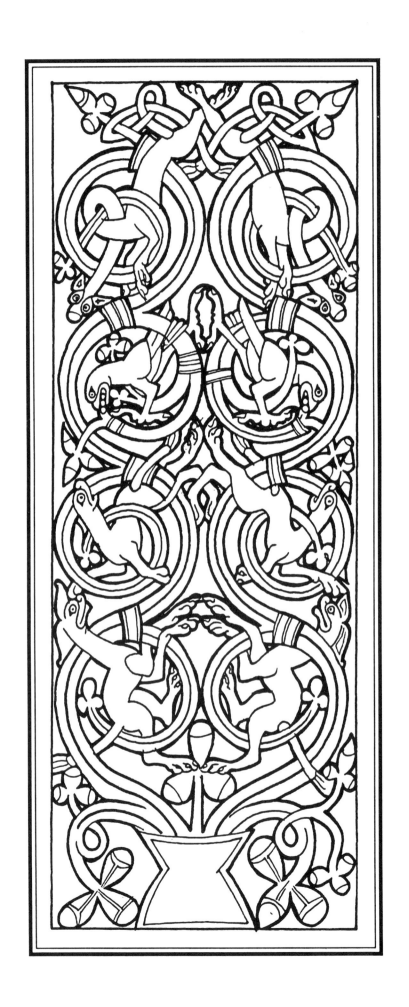

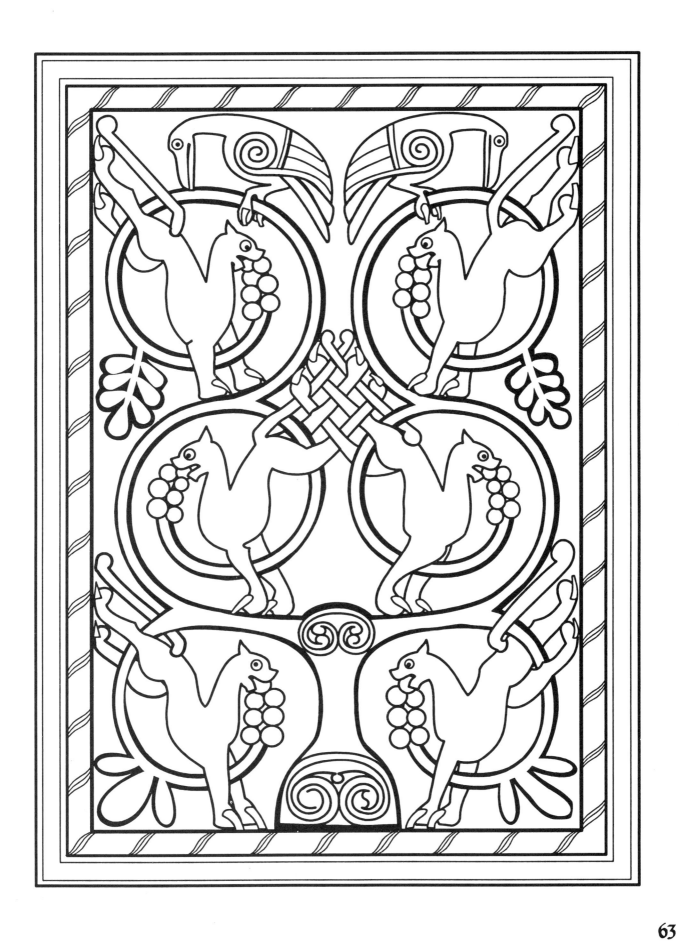

SOURCES OF THE ILLUSTRATIONS

The illustrations in this book are based on designs from my *Celtic Design Series*, enlarged and in many cases redrawn. There are some new, previously unpublished designs here, too.

1. Celtic Design: A Beginner's Manual
2. Celtic Design: Knotwork: The Secret Method of the Scribes
3. Celtic Design: Animal Patterns
4. Celtic Design: Illuminated Letters
5. Celtic Design: Spiral Patterns
6. Celtic Design: Maze Patterns
7. Celtic Design: The Dragon and the Griffin: The Viking Impact
8. Celtic Design: The Tree of Life